Dancing in the Kitchen

Dancing in the Kitchen

a prose collection

Jeanne Lohmann

For Andrea —
As promised, here's the
newest "gathering" —
Love,
Aunt Jeanne

October, 2006

2005 · FITHIAN PRESS, MCKINLEYVILLE, CALIFORNIA

Published by Fithian Press
A division of Daniel and Daniel, Publishers, Inc.
Post Office Box 2790
McKinleyville, CA 95519
www.danielpublishing.com

LIBRARY OF CONGRESS CATALOGING-IN-PUBLICATION DATA
Lohmann, Jeanne.
 Dancing in the kitchen : a prose collection / by Jeanne Lohmann.
 p. cm.
 ISBN 1-56474-450-7 (pbk. : alk. paper)
 1. Lohmann, Jeanne—Marriage. 2. Brain—Cancer—Patients—
Family relationships. 3. Poets, American—20th century—Biography.
4. Married people—United States—Biography. 5. Husbands—
United States—Biography. 6. Widows—United States—Biography.
I. Title.
 PS3562.O463Z465 2005
 811'.54—dc22
 2005003321

for those who lived these stories

and for those who encouraged me to tell them

CONTENTS

PART THREE: SINGING BACKWARD

PART FOUR: GRACE NOTES

PREFACE

After irreparable loss, words go only so far. Always, as the poet Galway Kinnell says, "There are things I tell to no one." Distance is essential for what waits to be told, if indeed it can be said. For years I could not find a way to say much of what is here, not sure if I could tell the stories true or say, and simply, "This is what happened, how I saw what happened." Nonetheless, I kept a record of sorts, notes on experiences that moved and strengthened me. Some of these belong to the three years of my husband's brain tumor illness, and after his death, when I wrote *Gathering a Life* and the poems of *Granite Under Water*. But I wasn't ready then to tell what is here, to place that life in another context.

Life pushed to its limits can admit us to a surprising and generous place. However clumsily, we exchange credentials, validate our kinship, remember who we are. There is among us an astonishing kindness, even as there is also the mystery of suffering that opens or hardens the heart.

Sometimes *in extremis*, past visible strength or wisdom, we are enabled to care for one another. Our difficult attention may become a kind of holy courtesy that changes the ordinary life into extraordinary community.

These stories, then, I give for the life that is in them. Each resists and compels my telling. I have tried to be faithful to those who lived the stories. In the lovely old word, I am *beholden*.

Dancing in the Kitchen

Part One: During

To love what is mortal;
to hold it

against your bones knowing
your own life depends on it;
and when the time comes to let it go,
to let it go.

—Mary Oliver, from
"In Blackwater Woods"

STRIPPING THE TREE

We leave a few apples. "For the birds," Hank says. He'd plant-
ed Bellflower in our backyard one Easter morning more than
twenty years ago. The skins are yellow and waxy, the flesh
solid, good for cooking. A gardener told us this variety is old-
fashioned, uncommon in San Francisco, said he'd seen only
one other in the city.

This autumn the apples are so plentiful we come with buck-
ets, paper bags, and boxes to gather the fruit and bring it in.
Unable to go higher, my husband sits low in the crotch of the
tree. As I pick, I move the ladder around the trunk, hand the
apples to him, shift the containers within easy reach. We fill
them all. The highest apples on the tree hang gold in the late
afternoon sun, bright against the dark branches, the leaves,
the blue September sky.

"Something for the gods," I say. Thanks for our married
years, like apples firm and sweet under the skin, the brown
seeds shining in the tough membranes at the core.

PRESENT TENSE

The phone rings, Hank's physician brother-in-law calling from Florida. Competent, caring, a man with a repertoire of dreadful jokes. This morning there are no stories.

Our options were narrowing. Scottie agrees that another surgery would provide essential information. "Go for it," he says. "Your research center in San Francisco is one of the world's best." He says the doctors might decide to forego more aggressive therapies and continue Dilantin to reduce seizures in the brain.

There is a long silence. "The die is cast," he says. "It's an honor to know you."

Love, and a small measure of hope. In the present tense. For now, enough.

DANCING IN THE KITCHEN

We have begun to say good bye
To each other
—And cannot say it
 —George Oppen, from "Anniversary Poem"

Hank is the better dancer. Confident, light on his feet. Dancing with him is easy, not the awkward adolescent embarrassment I often felt with other partners.

Now he's the awkward one, off-balance, coordination a problem. But one Saturday night, with the signature music of "A Prairie Home Companion" on the radio, he holds out his arms, asks me to dance. Supper in the oven, we dance in the kitchen.

Leaning his head to mine, he keeps me at a slight distance. My body aches to be closer, to hold him close, not to let him go. As we dance around the table, between the stove and the center island, I think of my friend Julie. How with three red satin bows from Christmas, she danced naked for her husband in the living room. Wish I could try *that*.

Yesterday for the first time he took the carved ebony cane when we walked at dusk through the redwoods. Standing under the big trees and, from some place in his head I couldn't imagine, he turned into a song-and-dance man. Like the old-time Scotsman, Harry Lauder, he began to sing "Roamin' in the Gloamin'," and tried a few fancy jigtime steps. Caught by his happiness, delighted by this rakish performance, I clapped my hands and laughed with him.

But his energy didn't last. He reached for my arm, and held on all the way back to the house.

AFTER PRUNING,
THE PARK ROSE GARDEN

Early summer, and by mutual agreement, unspoken, we three longtime friends do not talk of illness, his prognosis, or dying. We walk slowly arm in arm, and then Hank goes to the rubbish pile of spent roses. With deliberate care, he sorts through the stems and leaves, the blighted and discarded cuttings. Finds one flower that looks as if it might last: deep salmon pink, not quite past prime.

Shyly, and with an almost courtly grace, he hands the flower to Leonore, says: "For you, my friend." She doesn't trust her eyes, her voice, but she nods her grave and smiling thanks— for the fragrance and beauty of his gift, his delight in something saved.

NOVEMBER

Let us love better, children, it's most that's left to do.
—Emily Dickinson, *Letters* (#255)

Heads bowed around the table. From the feast, good smells rising: a mix of roast turkey, sage and apple, sweet potatoes, walnuts, the yeast and wheat fragrance from hot rolls under the blue-striped napkin.

Hank says grace, gives thanks for all of us, says: "Lord, you know how far we've come, you know what it takes to bring us home. We thank you for possibilities in life, for everything that helps us start over, helps us change and grow." Words better suited to spring, a different season. He knows, they all know, what his chances are, what the doctors said.

With every right to rage and shake his fist at God, to cry *it's not fair* and *why me*, he prays for the new child in his daughter's arms. For his aunt's tenuous hold on reality after the stroke, for friends down on their luck. For the homeless, the sick and suffering, people who have decisions to make.

When he says *amen*, we all say *amen*. The prayer goes on in silence that holds our love for him, and for each other, a celebration of harvest and hope with winter coming on.

DRIVER'S LICENSE

(His Side of the Story)

Glad the line isn't long. I sure am tired. Let's get this over. What's the point? I've been driving more than fifty years in all kinds of weather, crossed the country lots of times. Never had an accident.

But Doc said there are *indications*, whatever that means. He said the DMV should take a look at my medical records. Said it would be a good idea.

Glad Brian came with us on this fool's errand.

Did Jeanne turn me in because of last week's near-miss on the bridge? Guess I did veer toward the center line, a little close to the divider, but I thought I corrected the mistake pretty well. The other drivers moved in so fast. Nobody's patient anymore, everybody's in such a hurry. Yesterday some kids honked at me when I was driving out of the park. What was that all about?

Maybe I should rest more so I can concentrate better, pay closer attention to my peripheral vision. Maybe it's time to change medications. Did I remember to ask Doc Slyter about that?

The examiner was too fast. He just skimmed the report, didn't even ask questions, didn't give me a chance. So how can *he* know, holding out his hand for my license. Said if I get better, I can come in again, get tested for reissue. Big deal! How am I supposed to get around, anyway?

On the way to the parking lot, Brian took my arm. Opening the car door for me, he sat down in the driver's seat. Then this *boy* I taught to drive said with the rough edges sweet in his voice, *Dad, I'll take you anywhere. I'll drive you wherever you want to go.*

SERENADE

New Year's Eve. We go out early, to a new Filipino restaurant Hank wants to try. Festive and different, with live music. Perhaps he hopes the atmosphere will cheer us in these dragging months of his uncertain longevity. The restaurant's in the Clement Street neighborhood, with easy parking nearby.

I drive the new Toyota purchased six months ago, a car for me, my first car. Good safety features, automatic shift, less trouble on hills and freeway, in city traffic.

No other customers in the restaurant with its pink table-cloths, vases of artificial carnations, blue and white plastic chairs, a trio of musicians behind the piano.

We order, and while we wait for dinner, he asks what songs I'd like to hear. I draw my usual blank. In this situation, what music wouldn't make me cry?

I shrug my shoulders, and Hank smiles at my non-committal silence. Then, in his quirky, humorous way, he turns to the musicians, asks for "You Are Too Beautiful." An old standard they know, but they don't know his second request, "Jeannie with the Light Brown Hair."

Reaching across the table, he takes my hand. In these winding-down days at least he can give me music, a serenade. Songs he hopes will make me happy.

NOTHING

There is nothing I can do. He will go away. The sentence is given, the kind of death not indicated. Only that I have to stay here and cannot go with him. It is impossible. No matter how he loves his life, he will go away. There is nothing I can do. Winter kills are brutal, my life frozen in this ground. Not to be put to the test. Not to be left behind. Or to go with him, for his sake not to go with him. He will go, and there is nothing I can do.

IN CASE LIFE CALLS

Why imagine these scenarios, rehearsing his death? It's impossible to be ready. Death will surprise us, and I can't imagine *how* or *when*. Nothing happens the way we plan, no matter how many scenarios I invent. Maybe old people know this, those who live closest to their losses, trying to imagine which day they will die. When I try to imagine his dying, I know that I don't know a damn thing.

Dr. Levin says, "I can't be a prophet, a god. Cancer cells are unstable. If only we had the means to organize them. Most cells want to be healthy," he says.

So we are given this small belief, in miracles, in remission. Like laughter, the sun rising out of the dark. Today seems like any other day. Almost normal.

And I think of Florida Scott-Maxwell, writing at eighty-two: "I live by rectitude or reverence, or courtesy, by being ready in case life calls, all lightly peppered with despair."

DINNER FOR TWO

During Hank's cancer treatments, a friend arranges for meals to be brought to the house. It's hard enough to keep up with essential routine, medical appointments, much less shop and cook. Surprises come daily in lovely dishes, bowls, casseroles, or in disposable containers we don't need to keep track of or return.

This evening, when the doorbell rings, Rick is standing on the front porch. He wears the starched white jacket from his work as maître d' at the Balboa Café in downtown San Francisco. Carrying a tray covered with a red-and-white cloth, he sweeps past us and into the kitchen. Like a magician in performance, Rick lifts the cloth with a flourish: hot crusty bread, cassoulet, mixed green salad with walnuts and raspberry vinaigrette, pears in ginger cream, crisp cookies. A carafe of wine. And the sweet scent of white stock in a blue vase.

Bowing, he ushers us to the table, sets out plates, silver, cups. He asks for candle holders, and lights the yellow tapers. Each task done with ceremony and good humor, the easy flair we cherish in our handsome, dark-haired friend. We relish his wild jokes, his improbable stories. Rick knows how to laugh at himself, how to make his friends laugh.

Tonight our appreciation is enhanced by our concern for *his* illness, an AIDS roller coaster of blood-cell changes, experimental therapies. Once, comparing notes, Rick said, "I feel like I'm shopping for death," and he pointed to invisible objects on invisible shelves. "I'll take this, please, just a little. And none of that, thank you." He says the first thing to go was his sense of time, and he chuckles about the visitor who asked to use the telephone and found it in the microwave. Reading

recipes is difficult. He gets lost in the supermarket, has trouble making change. Parts of speech are confused, and the nouns are going.

But Rick will have joy in his life. While he has his life, he will live it, with *elan* and gusto, care for others.

With impeccable elegance, expertise in every gesture, Rick folds the linen napkin over his arm, bows one more time, turns to go.

RADIOLOGY WAITING ROOM

In the chair next to me, a thin young man is reading *Even Cowgirls Get the Blues*. While I wait for Hank, we begin to talk, and he tells me that his brain tumor is close to the optic nerve. "Even top surgeons won't touch it," he says. "Radiation has to be done very carefully so as not to damage my sight. There are points across the Marin hills where I have to fix my eyes so the rays will work. When I see those points, and I can't always find them, I tell the technician I'm ready. When they tell me to hold still, I hold real still."

SPILLING OVER

He asks, "Are things piling up too heavy for you to handle?"

I say no. But they are. In ways I can't tell him, they are. He has more than enough to tend to, adjusting to changes in his mind, his body, and he tries to keep his feelings to himself. He doesn't want to spoil such time as we have. I don't want to spoil it, either, but I want us to be real with each other.

My feelings *are* piling up: fear of failure, fear of failing him. Not being able to balance the checkbook or drive the car. Regrets about times I'd shut him out, given him "the silent treatment" when I was jealous, or hurt, afraid. Memories of my self-righteous judging. Every single thing I am sorry for.

Sometimes I resent his unabashed concern for me. Even, sometimes, his tenderness. As if he's refusing to deal with the terrible reality of our situation. He makes assumptions, puts me off with pat prescriptions, easy answers. He says love is what he's learning, an end to self-recrimination, misplaced blame. Urges me to allow *my* feelings, let them in and treat them kindly. His quiet courtesy rejects nothing. My anger creates the temporary illusion that things could be different.

Why can't I say what I am learning, all that is in my heart?

When he asks how I want him to change, I am ashamed. He is doing his best, and for each of us there is no better answer.

MAN IN THE OTHER BED

A week after successful brain surgery, one of Hank's room-mates is scheduled for discharge. John is more than ready to go home, and his daughter's waiting for him, but he needs to say goodbye to Ed, the high-school physics teacher who doesn't remember what day it is, or how long he's been here. Or his six months *prognosis negative*.

Outside in the sun there's another country none of them was sure he'd make it back to. John is one lucky man, and he knows it. Ed's confusion could be his own. He could be the one with the blank scared look in his eyes.

In regular street clothes, John looks and feels more like himself. When Ed comes into the room, John leans down, takes the smaller man by the shoulders. Ed's bones are sharp under his blue-and-white cotton hospital nightshirt, like the beginning stubs of wings poking thorough. The three men swapped a lot of bad jokes about what they made you wear in this place.

It's awkward, but John holds on, tries to catch Ed's eyes, make him look at him. Ed looks dazed, not quite sure of where he is, who John is. The he jerks away as if he's just remem-bered something. Barefoot, he pads away, his good right hand pulling at the back of the hospital gown. He's trying to keep the edges closed.

Following Ed into the hall, John finds a way to say it. From his bed Hank hears the promise:

> I'll come back to see you
> I surely will come to see you
> Count on it, Ed.

Not a graceful moment, and no way to undo it.

WHY NOT SAY WHAT HAPPENED?

He's awake, his partially shaved head lopsided with bandages. Waiting for Dr. Seiling, we hold hands. The surgeon said he thought we were home free, and he expected the pathology report to confirm.

Finally, the doctor comes. Bad news. Watching us closely, he says he is so very sorry. Explaining the test results, he answers the few questions we think to ask. When he is gone, I climb into Hank's hospital bed.

Pure facts were what we had to contend with now, the elegance of pure facts. We'd asked for straight talk and we'd been given that.

White cotton sheet, nubby-textured blanket. His bones under my bones. After major surgery, you aren't supposed to get into bed with a patient. But you do, yes, you do.
If there's any way to stop this violent shaking,
you do. If he's just been told *malignancy*, you do.
Your whole life says *do this,* says *you love this man*
and he may not live. Says *he's not a patient, he's my husband*
and I won't let him face this alone, be this cold alone.

When Dr. Seiling returns, he pulls the curtain around Hank's bed. Without words, a gift of privacy. The doctor squeezes my toes as he walks past and out of the room.

FRESH AIR

"Brain surgery one day, breakfast the next!" The nurse puts the tray on his bedside table. Last night, she told me, Hank had refused medication, insisted he was going to meditate. She says he seems to think he can get through this on his own, without help.

Sitting beside his bed, I listen to each halting, difficult word, write it down on a yellow notepad. Saving anything I can save as part of my complex hope that I will be able to tell him the funny things he's saying.

Like: "My nurse looks like she belongs to a punk rock group," and "That's an odd map of Florida." There's no map on the wall across from his bed.

When I hold the urinal, he chuckles, comments: "Good to the last drop." When somebody in the corridor says, "I'll see you later," he answers, "Okay, alligator." Talks about learning the value of a left hook, names Pappy and Leo, wartime Navy buddies. Says he fell into the ocean and scraped off an eyebrow. Propped against the pillows, he welcomes visitors like some imperial caliph, bandages shaped to a grotesque white turban that droops over his right eye.

The third evening after surgery, his niece Luisa and her fiancé come to visit. Hank's irritable, thrashing around in bed. He's had it. Throwing off the sheet, he slides his legs to the edge of the bed, shouting, "I've got to get out of here!" Mike and Luisa offer their arms and shoulders, maneuver him to the balcony door, and push it open to the night air and fog, the salt wind off the Pacific.

He's entitled to breathe a different air, get away from hospital smells. Entitled, if possible, to connect with his memories

of campgrounds, mountains and rivers, walks along Ocean Beach and in Golden Gate Park, bike paths and country roads in New England, canoeing in Minnesota Boundary Waters. We want him to remember pine pitch and stars, the wet smell of the earth.

But we can't know what he's feeling, if he's remembering what we remember. Or if the pull toward night and the out-of-doors is something older, a simple need for fresh air.

We know he shouldn't stand too long looking out into the dark. We know he mustn't get chilled.

TAKING CARE

Caring is the greatest thing—caring is all that matters.
—Friedrich von Hugel, from *Selected Letters*

Even when she knows I mean well, our daughter says I sound patronizing. Trying to encourage Hank's walk down the hospital corridor after his second operation, I say "Attaboy!" she says that's like talking to a child. Maybe it is okay for us, but she isn't sure. Her dad is doing the best he can, and he has that baffled hurt look on his face, like a small boy who's being punished and doesn't know why.

When Karen sings for him, he enjoys the music, and the other patients say they do, too. When Hank is no longer able to talk, she writes the letters of the alphabet and he points to make the words he wants. That's how he lets us know he wants to come home. We go to Dr. Seiling, and he says, "I don't care what you do." As if he know there's nothing more *he* can do.

The social worker arranges everything: transportation, hospital bed, around-the-clock hospice care. I ride with Hank in the ambulance, and I wonder what it's like for him, coming through the park, coming home. We take good care of him, the aides and nurses, our four children helping as they can. He lives a few more weeks.

In the months before his final surgery, he said, "If it looks like I can't make it, feed me less." Once when I was angry because I couldn't do everything, he told me, "Love and forgive yourself." Said he still believed everything happens for the best. He apologizes for the "trouble" he is causing, and even asks if he is a "cross" to me, wondering why I married him in the first place.

Words that break my heart even when I know it is his sickness talking.

"May the good Lord bless and keep us" is how we say goodnight. No other place to go. No safer place to be.

THE DOOR BETWEEN THE ROOMS

I can't stop crying, even with strangers in our house. I don't want him to hear, but there's no way to swallow these choking noises.

The hospice nurse tells me that hearing is the last sense to go. I know she feels for both of us: for my husband, her patient in the next room with his tubes and catheter, morphine dripping into his veins, total care, and for me, weeping at the kitchen table, my head in my hands.

The nurse gets up, closes the door between the dining room and kitchen, comes back and puts her arm around my shoulder. She says, "He wouldn't want you to hurt like this."

GOODNIGHT

The children come when they can, help turn their father in bed, measure medicines and water for the I.V., empty the catheter bag. Doing what is possible.

One evening late, Steve bends close, touches his father's cheek, speaks quietly and slowly next to his good ear:

> "I have to go, Dad. It's night
> Time to walk under the stars,
> remember the camping trips
> those wonderful times."

There is no response, no answering recognition.

From the other side of the bed, my eyes fill with tears. I can hardly see, and I can't look away.

FOUR A.M.

I don't remember what the men say when they introduce themselves. Is one named McMonigle? Men with empty faces. I wonder if what they have to do erases their usual expressions. Coming at all hours to pick up dead bodies and carry them off for medical research, cremation. Hank has willed his body for research.

Detached, efficient and gentle, the men seem in a hurry. As if they'd rather be anywhere but here, as if it's embarrassing to work with me in the room, watching.

Positioning the sling next to Hank's body, they roll him over and fasten the straps around his chest and legs. So he won't slide, I suppose. They remind me of rescue teams after accidents in the mountains. Strangers about to carry him off this precipice.

My husband isn't a big man, but his life is large, and my body is heavy with the terrible weight of his absolute going. Following strangers to the front door, I can't stop the question: "Isn't he too heavy for you to carry down the steps?" One man, who looks like our youngest son, turns toward me. "Ma'am," he says, "if you could see what we have to do, this is the least of it."

On the porch, in the gray morning light, how cold and empty I am as I watch them put my husband's body into the unmarked van. As if my entire life, our life, is in that body he no longer wants or needs, has no use for.

My own body sways backward, and Dave, our second son, is right behind me.

Part Two: After

We must carry the shadows
Of the dead with us
Wherever we may journey
And we must carry the light

—Sam Hamill, from
"Heart of Bamboo"

A WAY THROUGH THE TREES

One of these mornings bright and fair
gonna find my wings and cleave the air
gonna lay down this heavy load
 —American spiritual

The morning he died I cut a full-blown rose, Double Delight, took it with me on the path through the redwoods. Like a cathedral in changing shadow and light, this was a special place where we often walked.

During the treatment his doctors talked about *tumor enhancement*. As if enhancement meant he was getting better. Deceptive words, medical jargon, off-putting as the words Dr. Phillips used when he told me about the stillbirth of our first child, saying "You have just expelled the product of conception." Distant, unbelievable language that still made me angry.

But that morning of Hank's death the colors of the day were enhanced—the redwood needles a brighter green, sharper, well-defined; the dusty gray skewers of shish kabob eucalyptus clearly here; the glittering grains of mica shining in the stones; miner's lettuce holding its delicate white centers. Hank liked gathering the leaves for salad, brought them home in a plastic bag.

The rose was heavy, a hindrance. Thinking of Hansel and Gretel, I dropped the white-and-red petals on the path between the trees, uphill to the clearing.

ORIGAMI

On the two tips of their seven points, the red and green origami pinwheels stand next to Hank's photograph. They were sent by friends in Japan, and a long string of paper cranes. I place them with other treasures on the fireplace mantel in our bedroom: a blue glass fisherman's float washed up off the coast of Alaska; bird feathers, white, scarlet, and gray; a cairn of small stones collected while hiking on beaches and trails; clover heads faded from purple; water lily petals dried the color of old parchment; a pine cone empty as a deserted hive; bright Central American "worry dolls"; a green sprig of new-growth redwood from this morning's walk in the park.

Sunlight glances off the elegant piece of crystal a friend brought the morning that Hank died. I call it "Paradise" for the city of God I want to believe in.

BODY LANGUAGE

I'm beginning to understand what he may have wanted when he asked for *gentle* hugs. Maybe it wasn't only the fragility of his body, his hurting bones and skin. Maybe he wanted some physical acknowledgment that together we were learning the same things: how to hold on, how to let go. Lightly.

Maybe he wanted my familiar body against his and at the same time wanted to be able to let go of that body. And the claims of his own. So that each of us might, when that should be the way of things, go on without weight or encumbrance. Even our long married years, our good life together. Even memory, if memory would make me sad.

But all my wordless intent was to keep him. When I tried to do as he asked and not hug too tight or squeeze too hard, my willful body acted on its own, past reason stronger than my wish to be gentle. Bones and arms and breasts asserted claim to their passionate undeniable truth: *I love you. Don't go.*

GRIEF NOTES

Wherever you are now, *if* you are, you're not who you were, and I'm not who I was. I don't know who this person without you is. When I try to remember your body, your laugh, your voice, I can't. Nothing happens. I thought you'd send signs.

I mumble wishes, prayers, incantations, but I'm a conjurer losing power. Some evenings when I come back to our house, I forget to say goodnight to your photograph I still can't put away. If your picture weren't there, would I be reminded of you less?

Books about "the grief experience" describe it as a time of mourning, the period of weeping. As if grief is time-bound and limited, comes to a definite and certain end. This is my time for as long as I need it, and on my terms. Even when unexpected sadness undoes the most ordinary day.

You aren't here to tease me out of my doldrums. You can't celebrate the achievements of our children and grandchildren, commiserate over failures and bad luck. Only you know how it was. No one else can be so delighted by our history in the grandchildren's faces, so stricken by the loss of friends. We maintained our love, I think, through the "glad kindness" Yeats wrote of in his prayer for his daughter. Never "entirely beautiful," we found ways to be kind. Another *thank you* I wish I'd known how to say.

A friend put it exactly right: "Your grief will be special as your life was special. Nobody can tell you what you've lost." I don't want anyone to try. When people say, "What you went through gives me perspective on my life," I'm furioius. I don't want to be anyone's *perspective*.

LIVING BY FAIRY TALES

I have to spin gold out of straw and I don't understand the business. My rooms are piled with straw. With so much light around me, you wouldn't think I'd prick my fingers. But I do, and they hurt. I cry.

Cinderella went to the ball and came home alone in her pumpkin coach. Now that the prince is gone, I've hung my fancy gown in the hall closet and put on something more suitable for these days I have to live. Rumpelstiltskin didn't show up, and the elves haven't come to help the shoemaker.

While I wait, Morpheus is the one man I'm most attracted to. We make and keep regular assignations, and he reassures me there's still sleep-magic in the world. He lets me out of his arms only for this work that is mine, more spinning than I can do.

DREAM OF A WHITE PEACOCK

Who I was I can't go to. Who I am is who I'm looking for. And the white peacock screams *Vanity! Vanity!* The sealed borders of this country permit no escape. Even if I am brave and strong and have a wall to write on, words crawl away, looking for corners to hide in. They struggle to the edge and fall over. In this dark labyrinth the thread is unspinning itself back to the stopped mouth, the lost voice. Who I am I can't go to, the gate of memory unhinged, the white peacock fanning its tail in the dark.

HONEYCOMB

Not many steps from the street to the porch and the oak door with its heavy brass knob, a door that opens into a long hall splashed with sun, the rug warm with patterned roses. I'd forgotten they bloomed there, on the floor. And the gold afternoon, the honey light. In the full comb between the thin wax walls, I taste all this: particles of dust floating in the light, the smell of fresh-cut grass, the pink and green flocking on the curtains at the bedroom window. Outside, the sycamores stand along the sidewalk, all the way to the corner. The children come back, and the story begins.

VISITORS

The Timshians believe that stepping into your house
was stepping into a place actually populated by your
people, all of them, alive or not—the dead at least to
the extent they were remembered by anyone.
 —William Kittredge, from *Hole in the Sky*

The taxi pulled into the driveway. Four years since the master
gardener from Kyoto had visited us. Hank was alive then.
Looking through the front window, I watched Mr. Ueoto and
his friends come up the rose-gray terrazzo steps to the porch,
and to our blue front door. Answering the bell, I welcomed
the men into the hall, then into my sun-filled living room,
where they stood smiling at each other for awkward moments,
mistrustful of language, uncertain how to begin.

Mr. Ueoto looked around the room. Then he walked to the
fireplace and stood silent for long moments in front of our
photograph on the mantel: a picture taken last summer beside
Stow Lake in the park. His companions moved to join him.
With gracious and solemn attention the three men bowed: to
my husband's absence in the house, to his presence.

Turning toward me, they offered greetings, presented gifts:
a beautifully wrapped package of green tea; elegant, fine-
textured notepaper. Bowing my own thanks, I led them to the
backyard garden with its curving brick walk, a definition of
new space. I pointed to the recently planted Santa Rosa plum
tree, the flowering quince, the cineraria, the short-stemmed
Clusiana tulips. "Coming slowly," the master gardener said.

Then with the help of what he called his "miracle machine,"
a pocket calculator for translating Japanese into English,

he told me of his mother's death last year, told me about the garden at Ryoanji Temple in Kyoto where there are no trees or shrubs, no flowers. Only raked white sand, and fifteen rocks.

When he said that I hadn't changed much from the last time he was here, the others smiled assent. He said I looked stronger. "I'm glad to have seen you. Come to Japan," he said. Then they left my garden and house, returned to the taxi, still waiting in the driveway to take them to the airport.

SERVING TEA

When guests come to the house, one must offer something, and without disclaimer or apology. Like *white tea*, the plain hot water offered in poor homes in China, where visitors are welcomed with all that there is, served with ceremony in the best bowl.

My teapot is the color of old ivory, with faded gold ribbons looping the fat belly, a handle that fits my hand. Hank's Valentine gift from the 1940s, presented on a tray with his funny poem on heart-shaped green paper.

Our good marriage was poured into cups. Over and over. His preferences were for the milder brews: chamomile, blueberry leaf, clover. Mine steeped richer and darker: Irish Breakfast, Wild Mint, Earl Grey, Red Zinger. Yesterday I read: *Death ends all contracts*. Brian, our youngest son, told me, "Take good care of the teapot, Mom. They don't make them like that anymore."

When I pour tea for my guests, it is a celebration: thanks to life, thanks for his life, and for the one we had together. Thanks to the people in China I don't know. The ribbons on the teapot pull us in, the teapot warms my hands, the fine steam rising to mist on my glasses.

OTHER LIVES WALKING WITH ME

Can I take care of myself, this partial being who feels disembodied, a stranger? The gifts that help and bless me seem, as suddenly as they come, to disappear.

A gift of curiosity, yes, I have that. And hot rebellion that won't let me stand still like Lot's drab wife, looking back on my home in the burning city. The life I never lived crowds in, our life that was, and the life I live now. These lives walk with me, toward a new place, past pity or comfort or resignation.

Undoing myself by slow degrees, I lean into today's sunlight and into the winter shadows. Solitary, occasionally even zestful, I call up my own voice, send it across the room, the echoes resonant around me. Dancing barefoot on the Persian carpet, I remember my father-in-law's tears when he gave that rug to us, the trust and sadness in his face as he watched us strap it on top of the station wagon for the drive from Minnesota to California. The beautiful carpet had been in their home since the beginning of their marriage, for more than fifty years.

And I think, too, of all the feet that have walked here: children's feet, adults on hands and knees, hunting for scraps and Tinker Toys, Lego and puzzle pieces. I think of friends and visitors who sat with us in our living room appreciating the patterns, the elegant design. How well the blue and green and scarlet pile lasted through our moves westward, in the changing climates and varying degrees of light.

Now, when my body is going through its own changes, and my heart is hunting new directions, I want these lives acknowledged. I want them to meet in some imagined place where dancers entertain spirits in bodies, and bodies let go.

I want the singers up before sunrise and standing on cliffs. And at midnight, a gathering in the fire circle where stories are told and the creatures come close. Where the spirits are welcome.

CENTENNIAL PARK

It will do, this slatted bench beside the path, the green hearts of ivy shining in the dusty afternoon. A small cool grotto, off the street, with old trees, their leaves changing yellow as the sun shines through. Tears have been building all day, and I haven't a clue as to why. But I can't make it home without giving in, without letting go.

Walking past the summer lawns of other people's houses, their gardens, I think of what I've been putting off. One day I will have to find some isolated meadow or valley and lie down with the grass and the stones, under the wide, enveloping sky. Outdoors, alone, to cry out all my desolation over his death. Ten years, and I haven't yet *abandoned* my whole self to grief.

Oh, I've cried many times on many walks, thrown my body on the bed to howl and weep. Been overtaken in unexpected places: checking the safety deposit box at the bank, sitting in the car after shopping for groceries. Predictably, tears come with anniversaries, birthdays, expressions on the faces of our adult children, the timbre of their voices that catches me off guard. Certain words and phrases trigger tears, as flowers do, and music, the way the light falls in different seasons of the year.

But to go alone to some field or forest, to ocean beach or river, to mountain and camping country, and there to let him in and let him go, this I have not done. Would that flood release me finally, restore me to my place in the world? Would I then be able to accept my solitary life, give over the bedrock sadness, rejoice in the glory of the out-of-doors, be saved by all that lives *outside* my life, everything that does not need me?

Unfastening the straps of my backpack, I sit down on the bench in Centennial Park, ready to make a beginning.

CAMELLIAS

After the downpour days, I pick up the single petals. The camellias come apart in my hands, the rose and red turned brown by season and weather. Camellias are provided for, each with a gold-edged hole that connects the flower to the stem, a center that holds it together. From there, the petals let go. I would like to be so willing, to have the days and years of my life so connected. And when the time comes, to let go the too-early and windblown, the dry and shriveled. To fall apart on the way to my changes.

Part Three: Singing Backward

*We cannot live our lives constantly looking back,
listening back...but to live without listening at all
is to live deaf to the fullness of the music.*

—Frederick Buechner,
from *The Sacred Journey*

GREEN GROW THE RUSHES

Version of an ancient Hebrew folk song. With each new line, the preceding words and music are repeated in reverse order.

I'll sing you one-ho!
Green grow the rushes, ho!
What is your one, ho?
One is one and all alone
And evermore shall be so.

I'll sing you two-ho!
Green grow the rushes-ho!
What is your two, ho?
Two, two, the lily-white boys
Clothéd all in green-ho.
One is one and all alone
And evermore shall be.

Three, three, the rivals

Four, for the Gospel-makers

Five for the symbols at your door

Six for the six proud walkers

Seven for the seven stars in the sky

Eight for the April rainers

Nine for the nine bright shiners

Ten for the Ten Commandments

Eleven for the eleven who went up to heaven

Twelve for the Twelve Apostles

SINGING BACKWARD

Is there a sign Truth gives that we recognize?
—Robert Penn Warren,
from "Aspen Leaf in Windless World"

Prologue
 Early morning. So quiet, and I'm alone
 among the signs life sends me, messages
 I try to read: gray gulls, black coots,
 a feather on my shoe. Water falling
 into the lake, a burgundy rose, petals
 curled back in past-full bloom. The house
 where my husband let go of his life, the rooms
 echoing with his voice, that song:

 I'll sing you one-ho!
 Green grow the rushes, ho!
 What is your one, ho?
 One is one and all alone
 and evermore shall be so

One is one and all alone and evermore shall be so.

Last summer in Iowa, visiting a dying friend
who asked me to come, I walked to an abandoned farm,
found the front door skewed and hanging by one hinge.
Clapboards weathered silver. Fading wallpaper
with static green leaves, white lilies. Signs
I couldn't read: a work boot in the kitchen,
the woodstove missing its chimney pipe,
a 1966 calendar picture of Jesus, lantern in hand,
knocking on a carved door.

Months now since Hank died. And I tell myself:

> *There is always one word. Something*
> *you wish you could do differently.*
> *If only I could have read the signs.*

I'd like to be able to let them go, the dead
who keep coming back. I'd like to be able
to say *See you in the universe!* Live on that promise,
be like Noah with his double vision,
keep the dead connected by twos, and safe
inside the ark. But I can't change the rules.

I'll sing you two-ho!
Two, two, the lily-white boys
Clothéd all in green, ho.

I won't put the pictures away.
I need that green reassurance, happiness
still there, still here in signs I can recognize.
I keep a sign above my desk, a card
with my father's elegant handwriting:
There is no ordinance against happiness.
I say it out loud: happiness
must be a kind of courage.

I've filled the photo albums, put our life
in orderly sequence. As if it could be so ordered,
the years stacked like firewood for winter.
I'm not ready to put them away, fasten
the last of him under sheets of plastic.

Not when we stand in the Japanese tea garden,
a cloud of cherry blossoms overhead,
the rosy azaleas at our feet.
Not when we're laughing and sitting close,
the Finn Crisp and apples in front of us
on the rough picnic table,
Teleme and Sonoma Jack cheeses ready to cut,
the knife ready.

Not when I can find him
in front of the house that morning
Steve left for college, the family up early.
Hank wearing his blue-and-white *yukata,*
the wind caught in his hair.

My years are clothéd all in green, ho,
years of private signs, beginning with
that first recognition: *Live this life together.*
An incomplete reading, surely.
Who would have the courage to enter love
when it costs so much to lose it?

I'll sing you three-ho!
Three, three the rivals

A bear in the campground woke them
with his snuffling at the tent site.
His first thought was for the girl
in the tent nearby, under the big trees.
We were middle-aged, the girl was young
and traveling east with us.
He went to check.

He came back cold into our sleeping bag,
said, "There was a bear, its gone now."
I couldn't get back to sleep, images
were crowding in out of the dark,
and I named them *girl, husband, wife, bear.*
Then my feelings changed the signs,
turned them into *jealous, rejected, angry, afraid.*

Years later, I wish I could change them again,
go back to where I lay curled into myself,
his arm around my waist. Whisper
an incantation of undoing.

What I must not forget is the one we were.

What I cannot forget is the unique gesture,
the singular smile, words no one says the same way.

The dead no longer lay claim
to their bodies, the beloved disguise.
I must not forget the end: his body
shrunken, his bones showing through,
flesh worn away to spirit,
his song in the air.

And fact: this cold season
of gray afternoons, the white sun
jealous of color, giving nothing.

What I must remember is the one we were.

What I cannot forget is he won't come
and tell me how it is.

I'll sing you four-ho!
Four for the Gospel-makers

The signs said *love,* they still say *love,*
and it's all I can keep, a story
I tell myself, each time with the same
ending. There's nothing new in his recorded voice,
only that fixed, far sound.
And he's not listening to old mistakes
now the tent of his body is folded and down,
the stakes and cords put away in the canvas bag.
I'm beginning to see that I hinder his freedom
wherever he might want to go.
Going over the old times, too many times
going back, I'm standing in the way.

I'll sing you five-ho!
five for the symbols at your door

Fascinated by doors, I draw patterns:
squares and lines, the curving arches of small windows,
panels, ledges, peepholes. Brass knockers.
Polished doorknobs, deadbolts sliding into place.
I walk up and down the street, looking at doors,
try to take them into my mind, the possibilities.

In this world, a surfeit of signs. All these
comings and goings. And the Hound of Heaven
scratching at the door. One after another
the doors fall over like dominoes.
Black and white, the old duality.
And what of the double blank, the Unreadable One?
What of endings and beginnings, life crossing
the coded bridges of DNA, such microscopic bridges?
Doors fall like paving stones
that open and close on mystery,
a road I will walk a long time.

I'll sing you six-ho!
Six for the six proud walkers

Feeling my way through grief
I work water into the fine-grained clay,
find old forms, different shapes: a basket,
a bucket, a tough old boot. The clay is thirsty.

A hand is growing in my hands, thumb and fingers
elongating out of the gray lump, and reaching
for proportion. Finished and wet, the clay hand
opens on the bench beside me. It doesn't look right.
I study this odd gesture I've made. The hand
has six fingers. What can it mean, the extra digit?

Suddenly I know, and I read the sign:
he is with me in everything I do,
hitchhiker for the long road ahead, the sixth finger.

I'll sing you seven-ho!
Seven for the seven stars in the sky

Looking into the night sky, I think of angels
my mind rejects, my heart makes room for,
a song for what no longer is simple.

By Orion's belt I bless you
and by the Milky Way,
look for legend out of heaven,
watching where I cannot pray.

Your body's burned and scattered,
no one can tell me where,
no wish on any falling star,
no constancy in prayer.

The Pleiades compel me
to trace you in the sky
who once mapped constellations
to set direction by.

I sight along the Dipper,
try Cassiopea's chair,
the myth of strong Diana,
the Great and Little Bear.

By Orion's belt I bless you,
put on the hunter's sword,
confront the dark that yields
to song, a fragile word.

Let the stars be angels. Let them be
to be what they are. Keep me from asking
questions no one can answer. Let the faces
I have seen in this life be angels enough.

Not what's lost but what's left.
Refined by my angle of vision and memory,
what's left connected to loss, what's gone, staying.
His absence. His presence. His words
His hand in my pocket.

I'll sing you eight-ho!
Eight for the April rainers

But it's only February, early for lilacs
that won't wait on my words,
old roots that don't take hold.
My split life takes so long to mend.

All night, high winds roar in the bedroom chimney.
Today is cold for walking through the debris,
downfall leaves and branches, streamers of bark
on the ground reminding me of that other storm
five years ago, another winter of gale winds
and fallen trees we couldn't climb over.

This morning beside Stow Lake the gardeners
spade the edge of the trail, cut into packed earth,
pry it loose. New birds whistle familiar music.
Around the curve in the path, primroses.
Brilliant colors. Definite vital signs.

I take in the evidence that drips off the trees,
the mud on my shoes, the gray-green skewers
of shish kabob eucalyptus a soft weaving in the air,
tell myself that air's no fabric to poke holes in.
Air moves in us, moves us, folds us round,
makes room, takes us in.

I'll sing you nine-ho!
Nine for the nine bright shiners

New faces are shining in puddles,
new deaths this spring, more dying
the earth recovers from, the air shifting
to accept the dead. And my words for them,
my broken speech when I talk to the trees.

Talking about God, a friend dismisses doctrine,
says "The Incarnation has to go!"
I smile at this. As if it could, that easily.
The way bodies change when the breath
goes out of them, when light leaves the eyes.
Love comes bodily to us, a form of grace
in one particular shape, the double gift.

Choose light. Choose it as energy or particle,
light is the shining that enables us to see.

I'll sing ten-ho!
Ten for the Ten Commandments

No other gods before Me.
No god but *Spiritus Sanctus*.
The rest is derivation, a code.
Everything that happens could be God
speaking, breaking the world
into signs that say to the survivor:
pay attention, tell your story.

I'll sing you eleven-ho!
Eleven for the eleven who went up to heaven

But I'm here, and heaven's inside
and around me. My obligation
is to memory, to names I hold in trust
like candles set out at night.

I've heard that you can claim an unnamed star,
enter the gift in a registry, make the name official.
Naming's that power to find each other in the dark.

Say *his* name. Say other names,
for the living and the dead.

I'll sing twelve-ho!
Twelve for the Twelve Apostles

The camellias are blooming. I cut camellias,
Empress of Russia, from the anniversary bush
he gave me (how many years ago?). And flowering quince.
Around our yard so much rose and red.

A good day. It's been a good day.

Suddenly I'm crying, I don't know why,
and I'm crying. Overtaken.
The confirmation of tears takes me like a lover.

He's here, in the solid truth of his absence,
his dead unchanging presence alive in the primroses,
in the broken gold heart of the rose camellia,
its polished leaves.

It is to be like this, then: tears because the afternoon light
falls a certain way. Everywhere, signs and wonders,
signs I am slowly learning to read: grief, and good news.

I'll sing you one-ho!
Green grow the rushes, ho!
One is one and all alone

When the song ends I start to sing it again,
sing it backward, order the words and music
in holy succession all the way back to the beginning.

The green rushes. The still water.

Part Four: Grace Notes

What is the body?
Endurance.

What is love?
Gratitude.

What is hidden
in our chests?
Laughter.

What else?
Compassion.

—Rumi, from "All Rivers at Once"

CHAPEL AT LAVERNE

Missing Hank, and weary of the back and forth wrangling of decision-making, I walked to the campus chapel. Looking for what? Escape? Sanctuary? A place to be alone? This morning, remembering his suffering weighed me down. The pain lasted so long, and I could do so little. Since his death, the dying of so many loved others, the world's agony pushing me to my knees.

In the empty chapel, sunlight warmed the oak pews. Leaning forward, head in my hands, I wept—for everything I could do nothing about. For what he endured before he died. All that I could tell to no one, details nobody was interested in, or could hear. The ache of everything I couldn't swallow.

Sunlight shifted in changing patterns through the stained glass windows. Then, from somewhere I heard a voice, words that were distinct and very clear:

> *child child*
> * don't you*
> *know I can*
> * take care*
> *of all that*

I didn't know, but I was sure of what I heard.

TULIPS

When Ray came to visit, he carried tulips. They were orange-gold and rose, their stems and folded petals in a cone of cellophane.

He was a fine craftsman, my friend who had remodeled the kitchen when I moved into my Northwest house. Ray told me that when he worked there he felt my husband's presence, heard him saying: "Do your very best. For her." Ray said the voice was courteous, encouraging.

Hank died years ago. Another May, another spring. I'd gathered our life as best I could, gone on with my own as best I could. Ray had copies of my books. Maybe those stories and poems helped him to imagine what Hank might say. Ray said he didn't put much stock in ghosts or fairy tales, but he said this experience was different. He told me he'd had help setting the countertops and drawers at the height I needed, help in shaping the angles and curves for the shelves, maybe even a few suggestions for his graceful craftsman touches. Like the small corner space he made for the "Snoopy" character Hank had carved at a Quaker retreat.

I appreciated Ray's work, his devoted, compassionate spirit, and I was touched by what he said. Not altogether surprised, I was grateful for the affirmation of continuity in my new life. Grateful, too, for the tulips, their vivid colors reminding me of other springs, and of the new words I didn't yet know how to say.

SEA CREATURES

Cooked, the fish looked different, changed from the body of cool silver Francesca had seen flashing through the water only an hour ago. Our granddaughter was six, and she was hungry. The fish smelled good, would be good for her, her mother said.

Before eating, something was required. Nobody had told Francesca, but she knew it was important and serious, though she couldn't say what it was.

She looked at the fish on the plate in front of her and the surprising words came: "Thank you, fish, for giving us your life."

Her mother thought then of their morning walk on Ocean Beach, and of the intent expression on her daughter's face as she studied an empty crab shell. Thought of how Francesca knelt on the sand and talked to the creature who wasn't there: "It's all right, little crab. Mother Nature will give you a new body."

As if all you had to do was believe, say the prayer right out of your heart.

BEAUTY PARLOR

Facing the wall mirror from where she sits in the chrome-and-plastic chair, the woman sighs, complains: "Look at this face! These goddam wrinkles!" Frowns, shakes her head. Her mouth tightens.

From my own chair, I watched Joanie brush out the new perm, push the soft wave into place, reach for the hairspray.

The woman was a good customer, a faithful member of the parish. But Joanie wouldn't let her get away with this kind of talk. Not when there are so many to speak for: arthritic, housebound Lina; May, who called yesterday, home from her mastectomy, and wanting a shampoo and set; Louise, whose husband left her for someone younger; Anne, who's a widow after those years of caring for Tom.

More stories than Joanie can tell, women who need attention and TLC. She says if she can help any one of them feel better, at least about her appearance, she will do it. It's little enough.

But Joanie's "Irish" is up. She holds the woman's head between her hands like a fragile basket, combs the stray hairs into place, pats the top and sides, steps back, approves.

Then she says to the petulant woman, who is still frowning into the mirror: "There are many in the cemetery of the Holy Cross who'd be happy to have those wrinkles in such a face!"

KEEPING WARM

*"In people, life, I think heart—the inner kindness—is
most important.*
 —Alice Fulton, from *The Poet's Notebook*

Anyone could see that the woman was disturbed, her speech a
rambling repetition of complaints, blame. Ruthie had a repu-
tation for making the rounds, trying one church after another,
demanding help with transportation, finances, a long list of
medical problems.

After worship, as people introduced themselves, Ruthie
said it was cold in our church, and we really should provide lap
robes if we expected people to sit around and talk. Nobody
paid attention. We were warm enough, and we'd been warned
in advance about this eccentric woman with her unfillable
needs, her grievances.

Then Zena, a young woman from one of the outside rows,
got up, lifted her green fleece jacket off the back of her chair.
She carried the jacket around the outside edge of the circle to
where Ruthie sat. Zena smiled, put the jacket across the wom-
an's lap, tucked the sleeves under her knees, and walked back
to her seat.

Watching this, my worship changed. In most situations,
there's *something* we can do.

IF I CAN'T, THEN I WILL

A slender man in faded Levis, leather belt with silver buckle, cowboy boots, a wide-brimmed hat protecting his skin that was cancer-prone after years in the sun. Proud of his roots in Arkansas, his part-Cherokee blood, he was quick to tell all comers that he never liked California. Or this small town he's trapped in. "There are good people here," he said, "but it's not my place." He missed the open miles, his horses, the mountains, hunting bear and cougar.

Here he and Vi had their twice-a-day walks, TV, occasional trips to visit family. They had Patches, a feisty black-and-white cat. Paul liked to pull a piece of string down the sidewalk so he could watch her stalk and then pounce with cuffing, playful paws. She didn't like to be held, and Paul laughed at the scratches on his arms.

He cut the grass, cared for the landlady's roses, did small repairs for the neighbors, and helped his wife with her periodic rearrangement of the furniture. Vi loved to shop, but she didn't drive. Paul kept their car and camper in top running order. Ready to go.

When his eyes began to blur and the doctor told him not to drive on the highway, he paced for hours back and forth in front of the apartment complex. He and Vi took longer walks, to the town limits and into the country, almost to the freeway.

Paul and Vi were good company for my mother, Lillian, their next-door neighbor. At ninety-two, Mother's health was failing, and sometimes she was lonely and scared, no matter how often we came to visit. Mother was lively and sharp, a good listener, and Vi loved to talk.

Paul replaced the wheels on her walker, installed a handrail by the front door, cut down the legs of her bed so she could more easily climb in and out. He was on call for grocery shopping, took her to the beauty parlor, the bank, did her laundry in the back utility room. When Mother insisted on paying him, he accepted. He knew it was what she wanted.

When we tried to thank him for his years of kindness, Paul said, "I always say if I can't help myself maybe I can help somebody else."

ACCIDENT

Embarrassed, Mother thanked the nurse who cleaned her after yet another *accident*.

She told me she wanted to die in a way that suited that life, everything she'd done and been, and was. She said she wasn't worried about what comes next, or *after*. She only wanted to get through this here and now with as much dignity as possible. She couldn't help being the bother she knew she was. No way to control her body, and damn the Depends! She wore them, when she remembered. Couldn't go anywhere now without the walker she'd named Jimmy, after her favorite horse when she was a girl on the family farm in Ohio. How long it had been since since she'd seen a horse, much less gone riding in the fields!

The day nurse unfolded a new square of blue plastic, maneuvered the pad across the sheet, positioned the bedpan.

Her name was Evelyn, and she looked very tired. Mother smiled, patted her hand, said: "You take such good care of me. Now how are you? How are *you*?" Mother turned in her bed, shifted her weight so she could hear, waited for the answer.

APOLOGY

A dull, persistent sound, the roar coming closer, the sea pushing her down. Cousin Bill said that's the way his mother said it was, said she kept turning her head toward a surfbeat in her ears. She told him its echo was like the one in the pink-and-gold queen conch shell they used as a doorstop in the family parlor. His mother used to lie on the floor and listen to the sound of the ocean in that shell.

But now Bill says Aunt Annie thinks she sees her high-school teacher in the hospital room. She says she sees Mr. Matheny standing at his desk in front of a green blackboard with white chalk marks, the sunlight through the high classroom windows making a path across his sandy hair, his face. She told Bill that he looks kinder. The teacher is saying that ocean water and blood have the same saline content and it is all a great mystery, and when you listen to a shell, what you hear is the pounding of your own heart. Aunt Annie said she didn't want to leave the pulse-beat of that singing.

Cousin Bill told me this, and then, finally, the rest. How he sat beside his mother's bed at the last, how her breathing came hard. Out of her dry mouth, in the trough of the waves between breaths, he said her words kept dropping off like little boats:

I'm sorry tonight I can't fix your supper

Bill said he could only squeeze his mother's hand. I wonder if Aunt Annie knew why he was crying, or why she couldn't comfort him.

HOSPITALITY

"Please walk in the garden. Stay as long as you want. Talk to the plants. You know, the birds answer human singing. If a stone asks to be picked up, do. I think that we owe courteous attention to the things of this earth."

I accepted everything offered: Betsy's words, the gift of this sheltering house, my room with clean linen on the bed, a blanket against evening chill, fresh fruit in a blue pottery bowl, books on the nightstand, key on the dresser.

Days later, saying goodbye, Betsy's husband told me what the Eskimos say to a departing guest: "You have honored my house." I cherish Joe's words, say them often.

FOR THE RUSSIAN WOMAN,
SINCE THERE WAS NO
LANGUAGE TO SAY THIS

Moscow, 1987

The international peace-marchers came down the gangplank at the Volga River landing, their long walk accomplished, their faces shining with mutual affection, and respect. There were banners, balloons, flowers, colorful costumes, dancing by children, music, official speeches.

After the program, out of the crowded crush of bodies, you came toward me: a stocky, imposing woman, not very tall, with straight gray hair pulled back from your lined face. Smiling, with your gold teeth. Your brown army uniform from the Second World War showed ribbons in rows across your chest.

I don't know what you wanted to say. I wanted to tell you that no war is worth the deaths of children, but I was able only to mention my husband, *moi muzhe*, who died two years ago. When I said the Russian words, you nodded as if you understood.

But I had no language to tell you more. I wanted to hear *your* story, about your life in that war, what your battle ribbons meant then, what they mean now. I sent my husband's ribbons back to the Pentagon, a protest calling for an end to my country's complicity in the killing in Central America.

But I don't know, really, what saves us. Perhaps our embrace in the middle of the flags, the noise, the music. We didn't know each other's names, only the hope we shared: for the dancing children on the boathouse steps, and for the gathered, nameless dead.

ON ONE OF THE STREETS
NAMED FOR HEROES

Hungary, 1996

He came toward me on Budapest's Hunyadi Janos ut, talking a torrent of Hungarian as if he expected me to understand his language of k's and v's in unfamiliar combination.

His dark, checked trousers with their worn cuffs didn't match his jacket, the elbows and pocket-flaps shiny with wear. His collarless shirt was frayed at the neckline and yellow, long past white.

Voice rising, he clenched his fists, held out his hands, the fingers stubbed off at the first knuckle joints. With a hacking noise, he pointed to the back of his neck. A few words came through: *Germans. Stalin. Hiroshima. America.*

He wasn't a beggar. He didn't ask for money. He seemed to want something else. His eyes said: "*Look* at me. Pay attention. Hear *my* story."

I wanted to hear, and I tried, but how could I translate my heart into my eyes, my face? Or into the hand I placed on his shoulder before he turned and walked away?

OASIS: ROSES IN TASHKENT

Uzbekistan, 1987

In the Uzbek valley of the Chirchik River, Tashkent is an oasis in the encroaching desert. After our long flight through eleven time zones, the airport is welcome as any caravansary on the old Silk Road. Outside the small terminal, the ground is cracked from baking in the sun. Roses planted by the walkways droop in the hot dry air.

A day later, at a *chaikhana*, a teahouse, we come into open rooms, cool arbors, long gardens. Seated on cushions at low tables, we drink green tea, *zelyoni chai*. Our guide tells us it is good for every ailment in the world. Even radiation sickness, she says. Behind us on the walls are beautiful rugs with intricate designs in blue, red, green, trailing gardens of vines and flowers, stars. Pattern with no visible beginning or end.

The hostess comes toward us. Her cotton dress is the color of ripe apricots, her blue-and-white flowered pants visible below the hem, a triangular scarf tied around her black hair. In her arms she carries red and yellow roses, their strong sweet scent the essence of hospitality's ancient tradition in this desert country. She smiles, gives us the roses.

We divide the flowers, take them to our hotel. The petals wilt in the heat; their fragrance fills the air, enters our dreams. In the morning, I place a yellow rose between the pages of my copy of *Fodor's Guide to the Soviet Union*. A gift I take home.

CARGO

On a California hill overlooking the sea, I read to the birds and
the sky, the insects: the poems of Seferis, Greek rhythms out
of the earth. Around me the gold grasses move like the
Aegean, and the wind lifts sail over cargo heavier than I bar-
gained for. My heart cries *beauty, beauty*. I can't remember a
time I was ever thankful enough.

NOTES

PREFACE

Galway Kinnell's poem "There Are Things I Tell to No One," is from his *Selected Poems*, published by Houghton Mifflin, 1982.

The allusion to exchanging credentials comes from "Flight to Arras" in *Airman's Odyssey* by Antoine de Saint-Exupéry, published by Reynal and Hitchcock, 1942. ("What was honored was not the individual himself but his status as an ambassador of God.")

PART ONE

Mary Oliver's "In Blackwater Woods" is from *New and Selected Poems*, Beacon Press, 1992.

George Oppen's "Anniversary Poem," the epigraph for "Dancing in the Kitchen," is excerpted from his "Some San Francisco Poems, #4" in *The New Naked Poetry*, Bobbs-Merrill, 1976.

The Emily Dickinson quotation for "November" is from her *Letters*, published by Belknap Press of Harvard University, 1976.

The Florida Scott-Maxwell reference is from *The Measure of My Days,* published by Alfred A. Knopf, 1968.

The epigraph from Friederich von Hugel is quoted by Douglas Steere in *Doors into Life: Through Five Devotional Classics*, Harper, 1948.

PART TWO

The opening epigraph is from "Heart of Bamboo" in Sam Hamill's collection *Gratitude,* BOA Editions, 1998.

William Kittridge's epigraph in "Visitors" is from *Hole in the Sky*, Vintage, 1993.

PART THREE

The opening epigraph is from Frederick Buechner's *The Sacred Journey*, HarperCollins, 1982.

The quotation from Robert Penn Warren is from *Being Here, Poetry 1977–1980,* Random House, 1980.

PART FOUR

The opening epigraph is from *The Essential Rumi,* translated by Coleman Barks, HarperCollins, 1995.

In "Keeping Warm," the epigraph is from Alice Fulton's essay in *The Poet's Notebook,* W.W. Norton, 1995.

ACKNOWLEDGMENTS

"Honeycomb" appeared in *Rosebud.*

Parts of "Singing Backward" were published in *A Small Box of Poets,* a limited edition from Protean Press, San Francisco. "Night Song" in Section Six appeared in the newsletter of the Washington Poets Association.

"Sea Creature" was published in *Barnabe Mountain Review.*